This book is a joint work by Chaz D. Bruce and Ashley M. Lanina.
Illustrated by Ashley M. Lanina.
Concept inspired by Chaz D. Bruce.
Published by Ashley M. Lanina
Copyright © Ashley M. Lanina
ISBN: 978-0-9984183-4-6

The Brucegang Coloring Book

An AHint Creation

Illustrated by Ashley Lanina

Inspired by Chaz Bruce

Check out the coloring book playlist on the chazbruce0 TikTok page.

Creators Info:

Chaz:

 chazbruce0

 chazbruce0

 Chazbruce0

chazbruce20@gmail.com

Ashley:

 amlanina

 ashleylanina

amhint@gmail.com

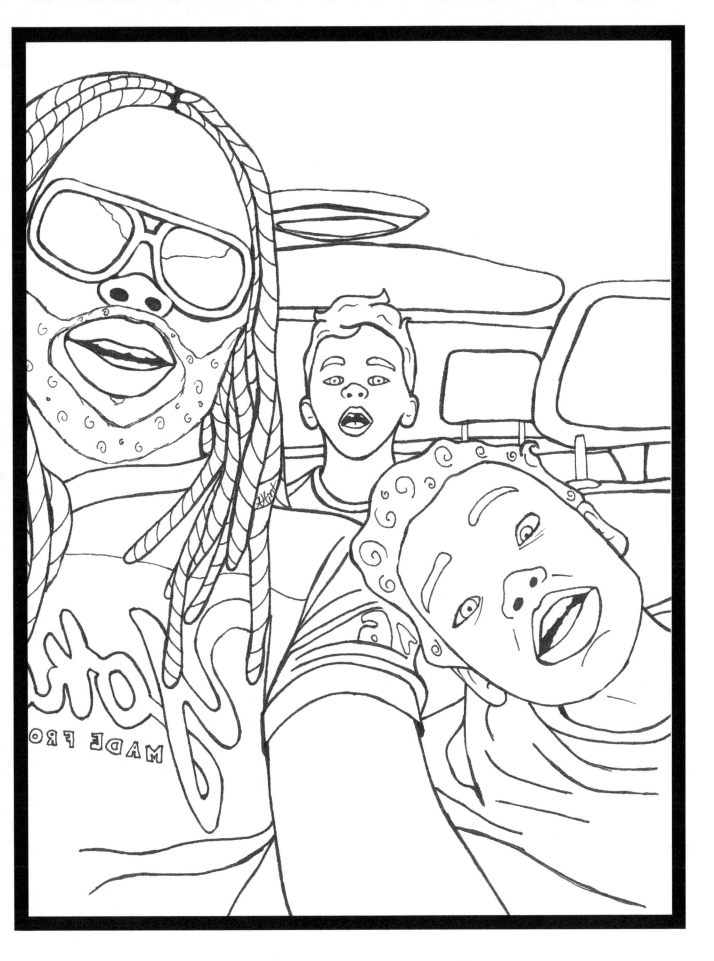

The Bruce Boys.

Chaz with sons Myles & Ellis.

Inspired by a chazbruce0 TikTok.

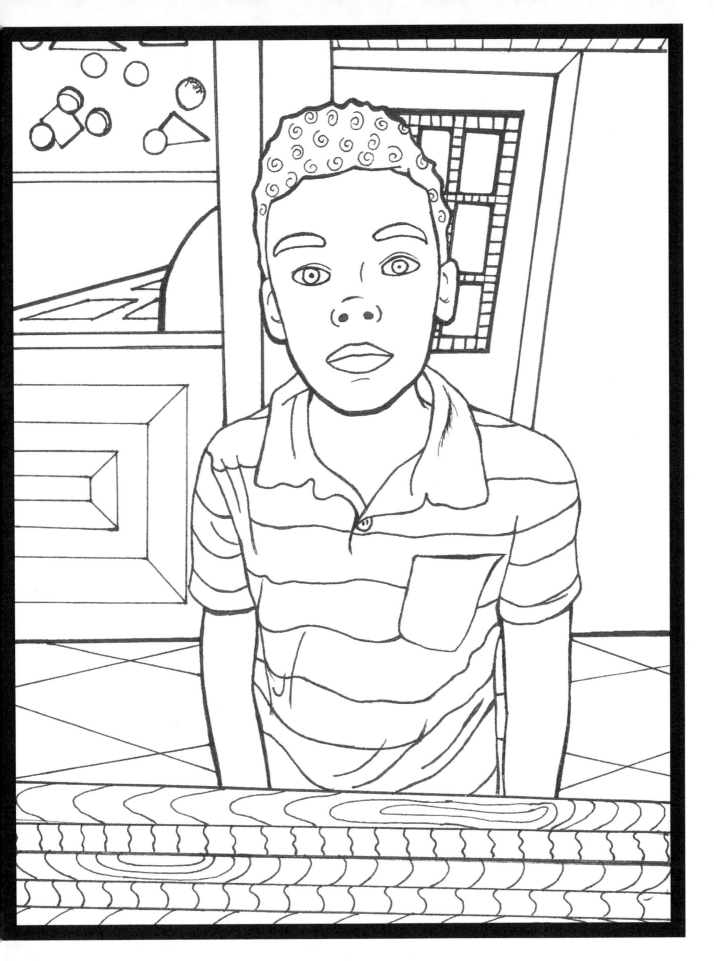

"Welcome to Dimpus. Can I take your order?"

Inspired by a chazbruce0 TikTok.

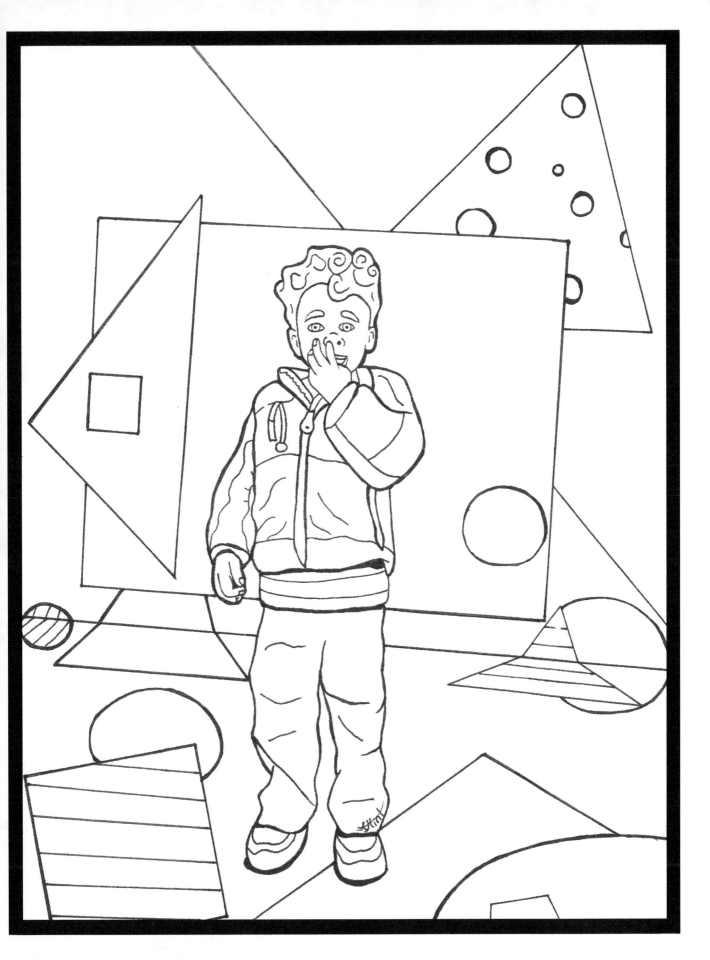

"Let's do the fork in the garbage disposal!"

Inspired by a chazbruce0 TikTok.

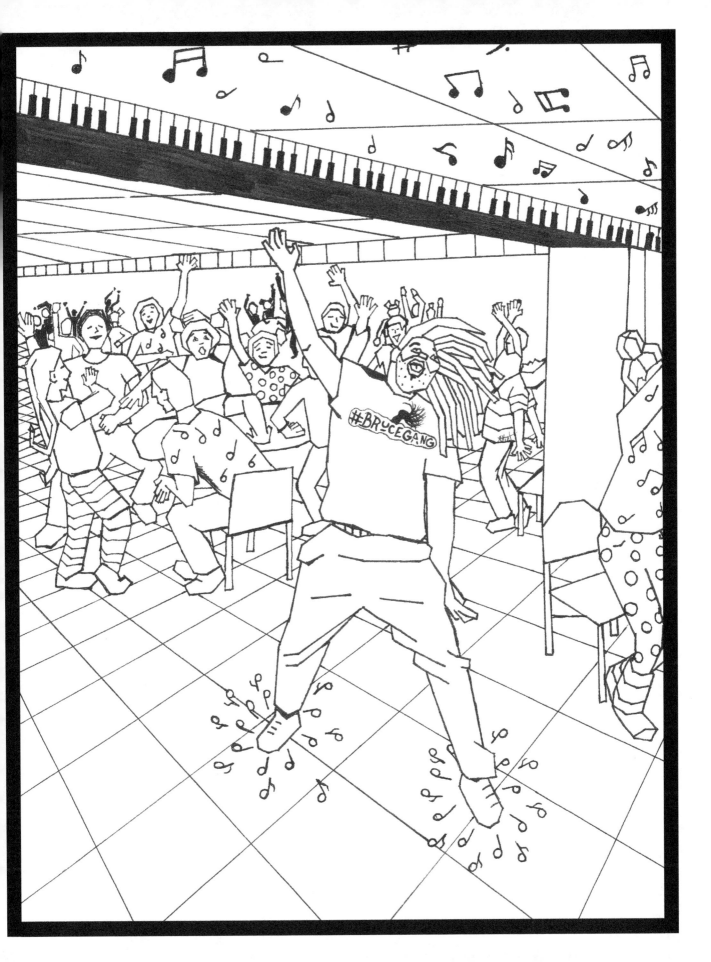

Rock to Change.

Inspired by a chazbruce0 TikTok.

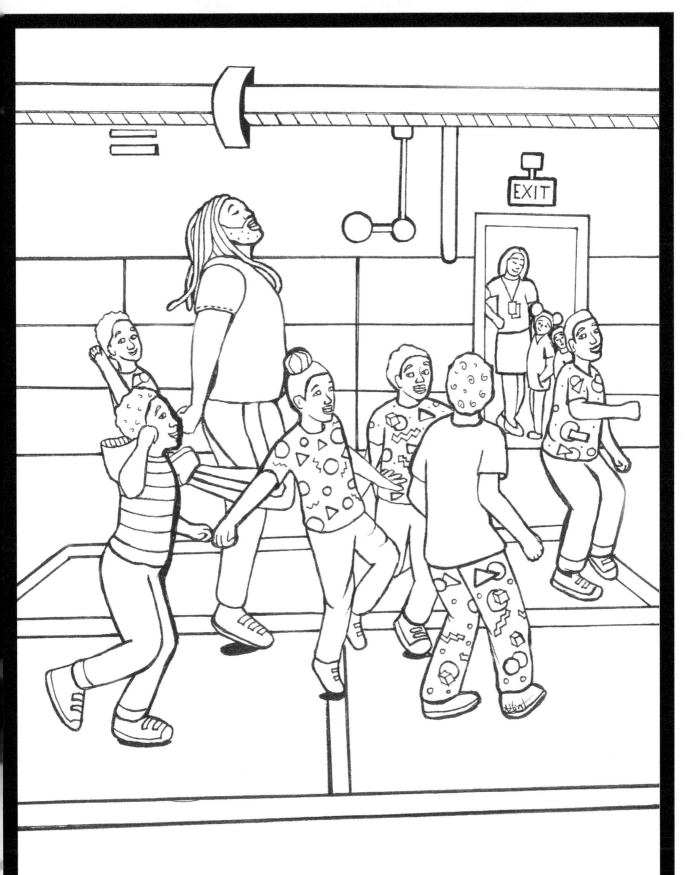

Principal caught 3rd grade TikToking.

Inspired by a chazbruce0 TikTok.

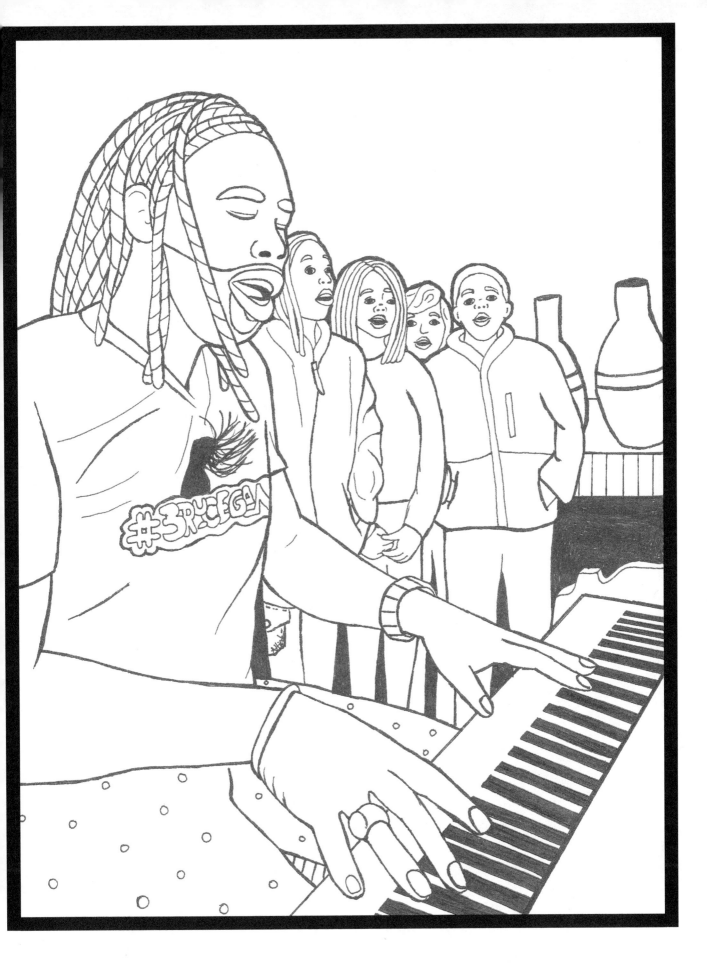

"I want you to be happier."

Inspired by a chazbruce0 TikTok.

"Covid-19 be like."

My six year old daughter got to pick her favoirte TikTok for me to illustrate.
She chose the only creepy one. -Ashley Lanina

Inspired by a chazbruce0 TikTok.

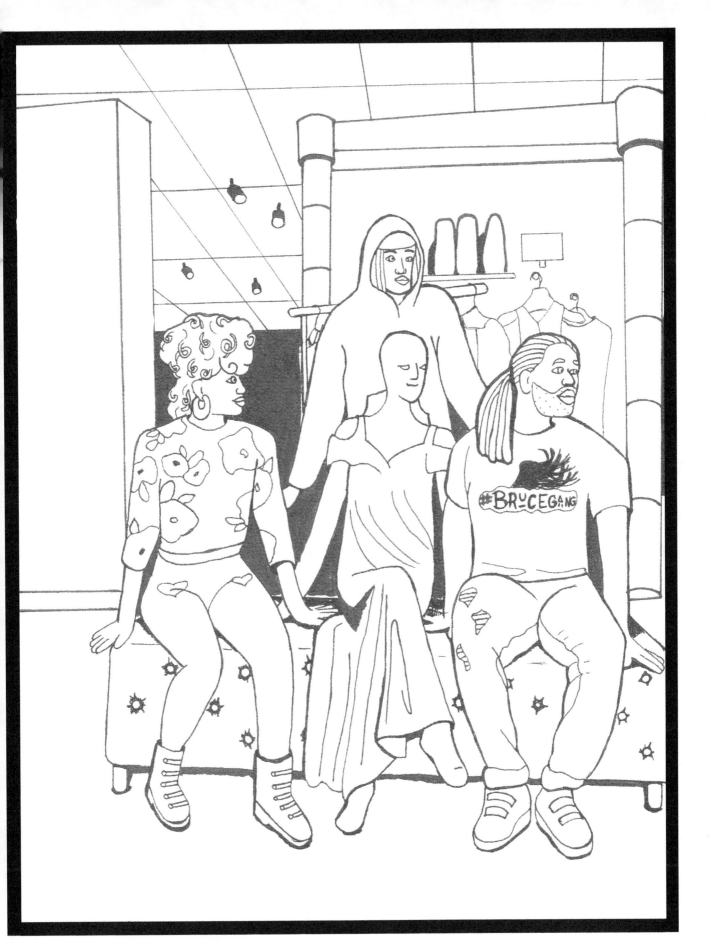

"Cha Cha now y'all!"

Inspired by a chazbruce0 TikTok.

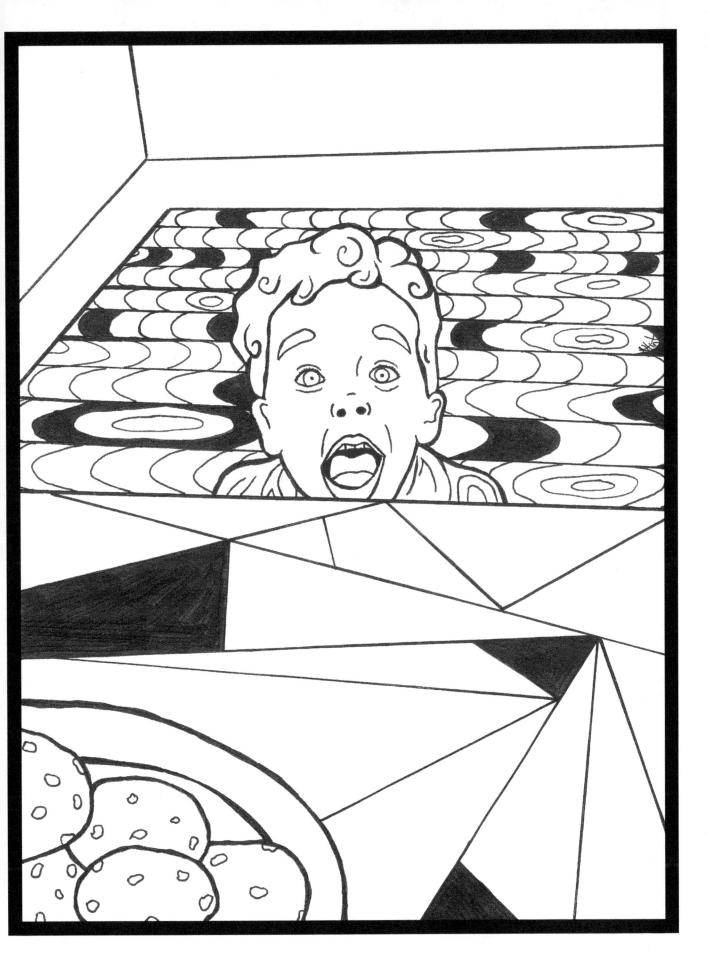

The Cookie Theif.

Inspired by a chazbruce0 TikTok.

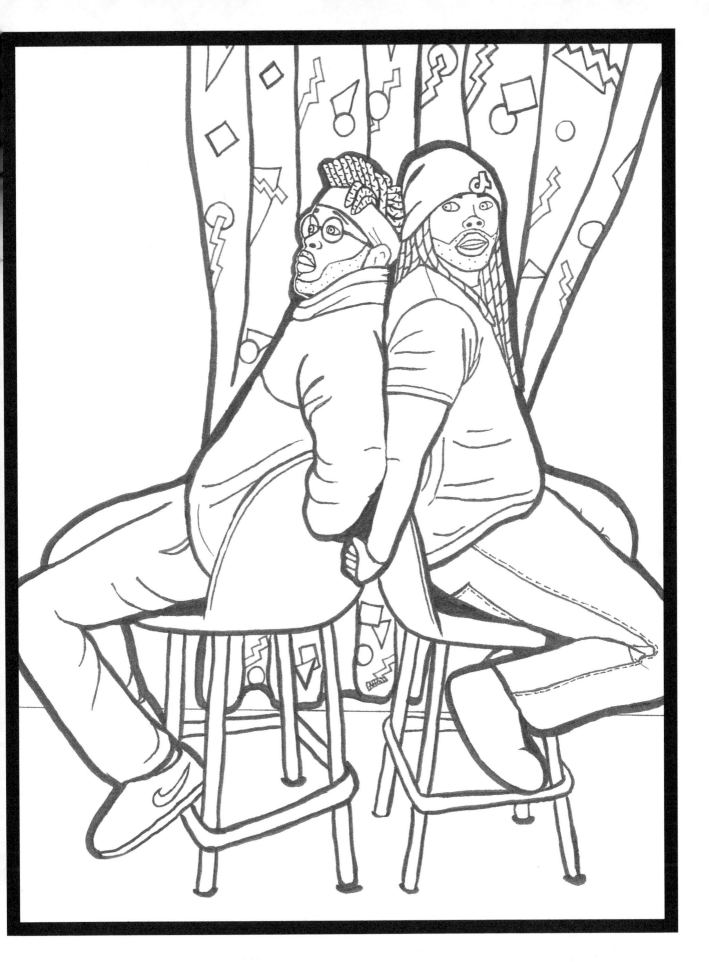

"You go this way, I go that way!"

Inspired by a chazbruce0 TikTok.

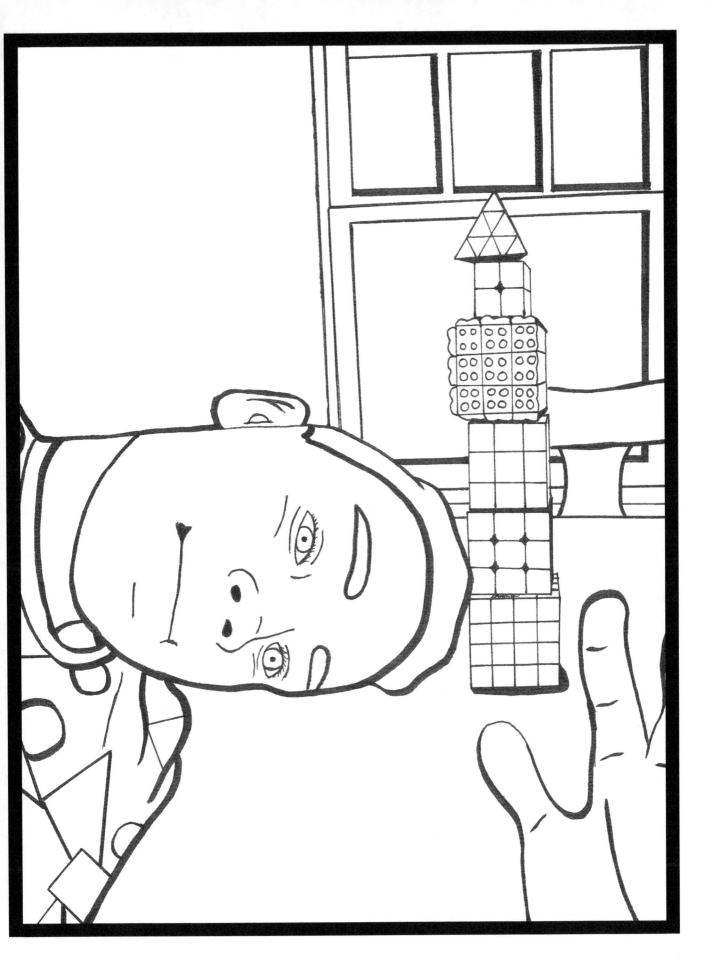

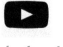

@mylesthecuber

Check out Myles the cuber on Youtube!

Inspired by a chazbruce0 TikTok.

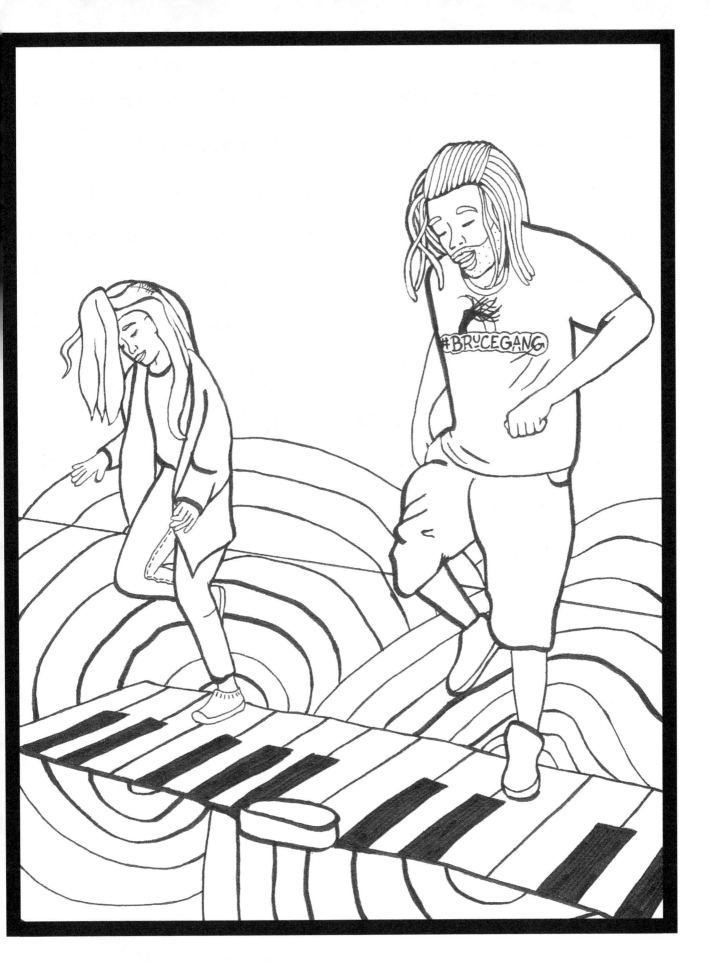

Mr Bruce's Music Class.

Inspired by a chazbruce0 TikTok.

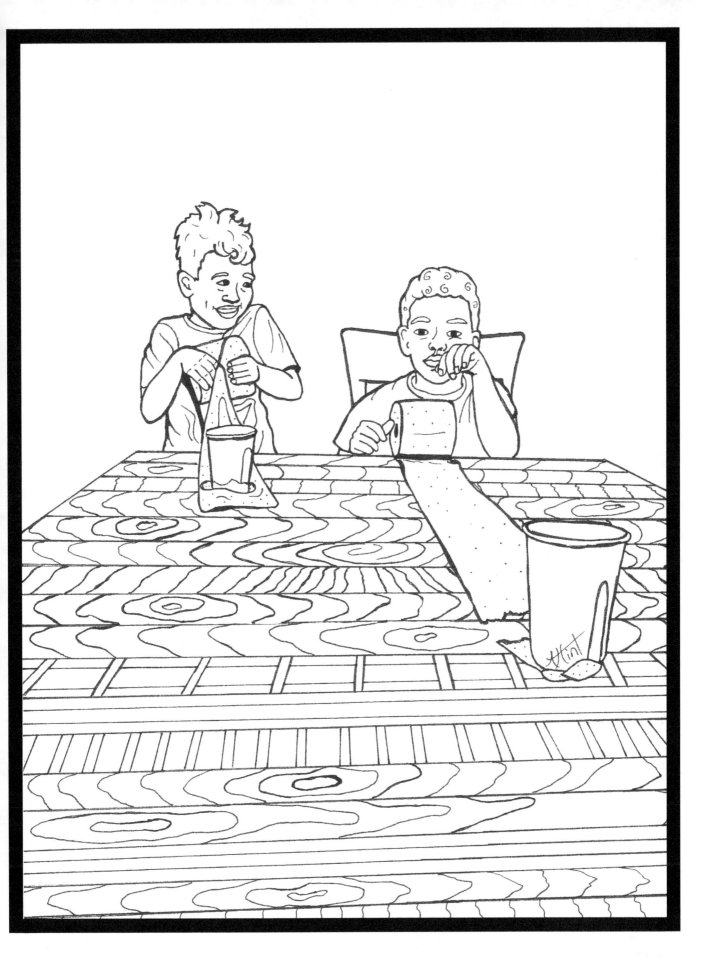

Home school games with Myles and Ellis.

Inspired by a chazbruce0 TikTok.

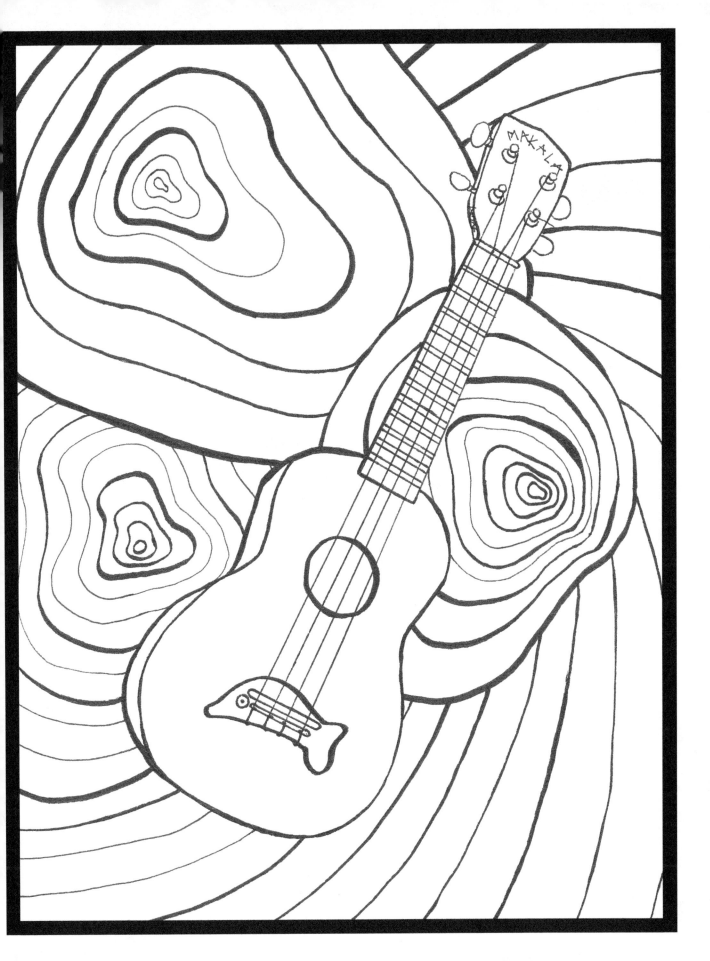

Chaz's Ukulele.

Inspired by a quick photo from Chaz.

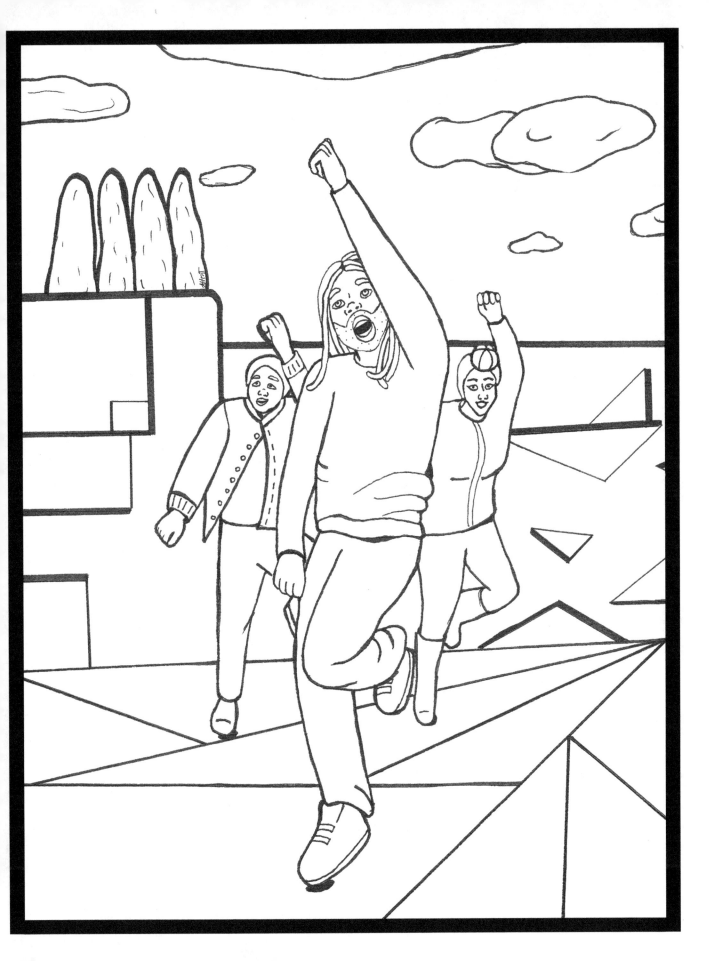

Smeezing with the parents.

Inspired by a chazbruce0 TikTok.

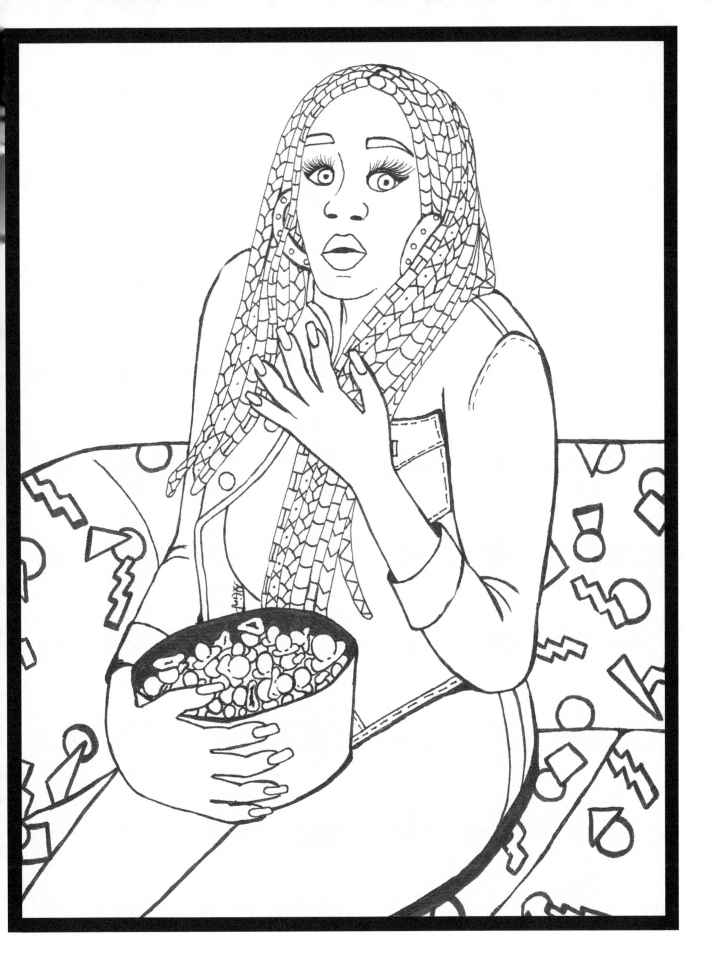

It's my Cheeto Popcorn!

A TikTok with sister Ky Bruce.

Inspired by a chazbruce0 TikTok.

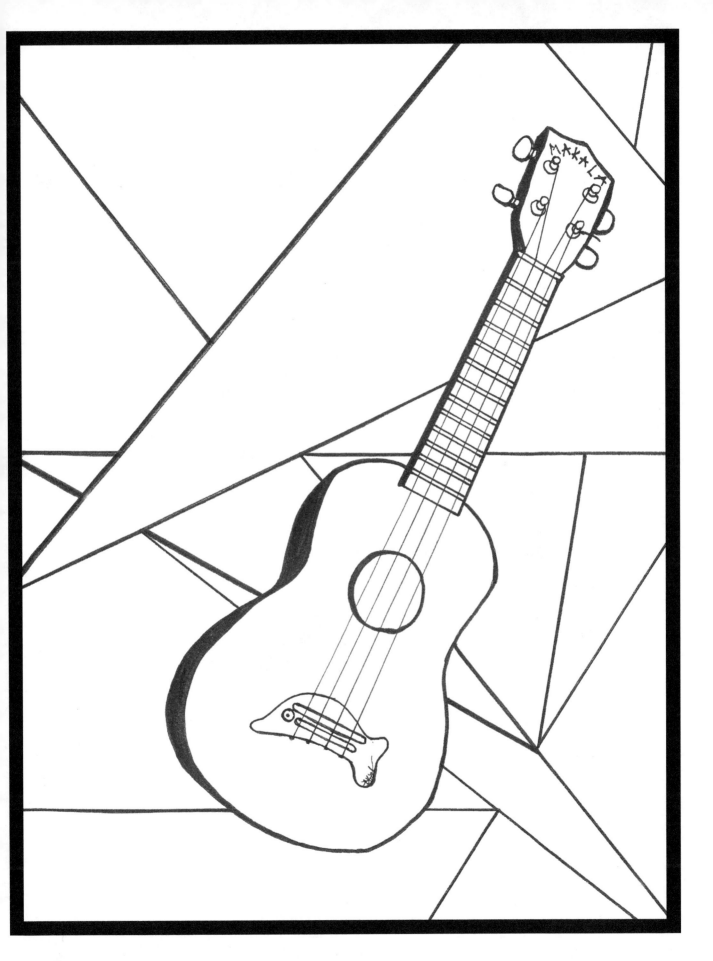

Ukulele.

Inspired by a quick photo.

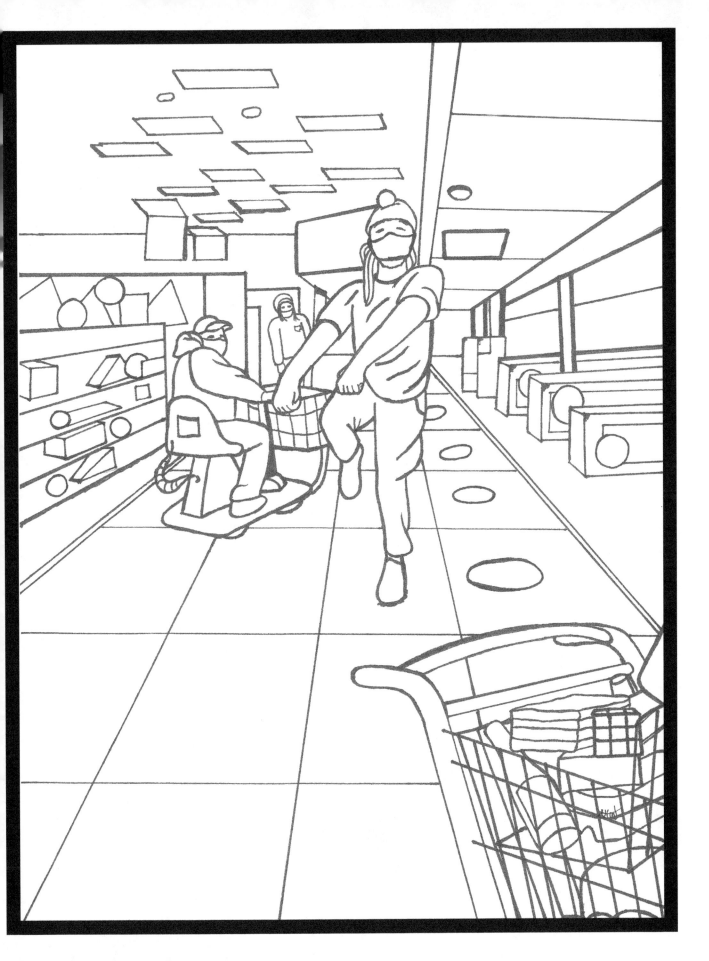

"Mufasa!"
"Huh?
"Show me somethin!"

Inspired by a chazbruce0 TikTok.

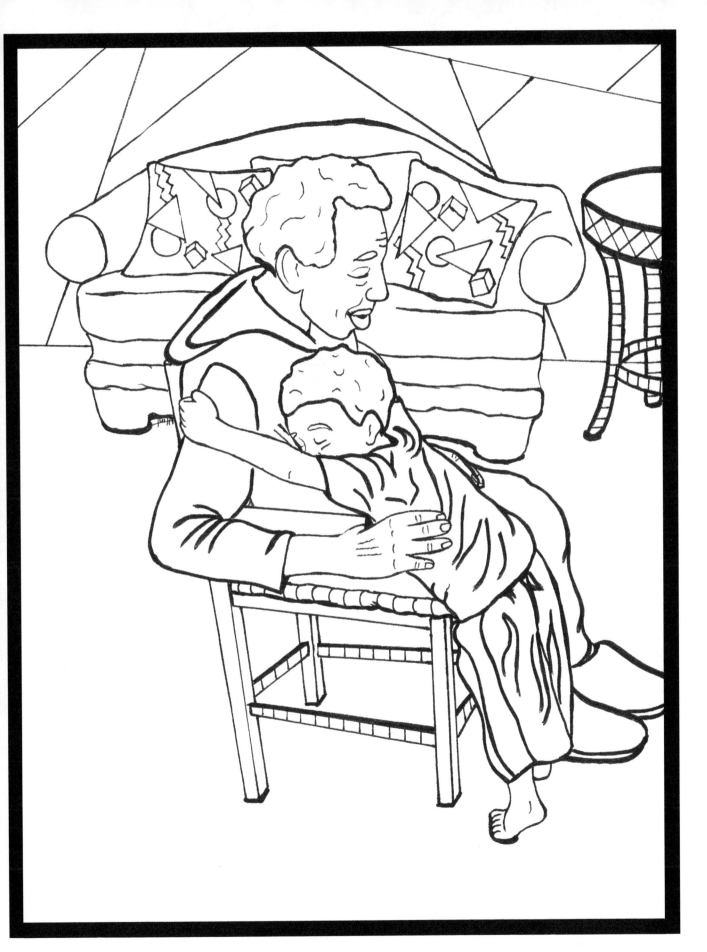

George Bruce with great-grandson Ellis Bruce.

Inspired by a Bruce family photo.

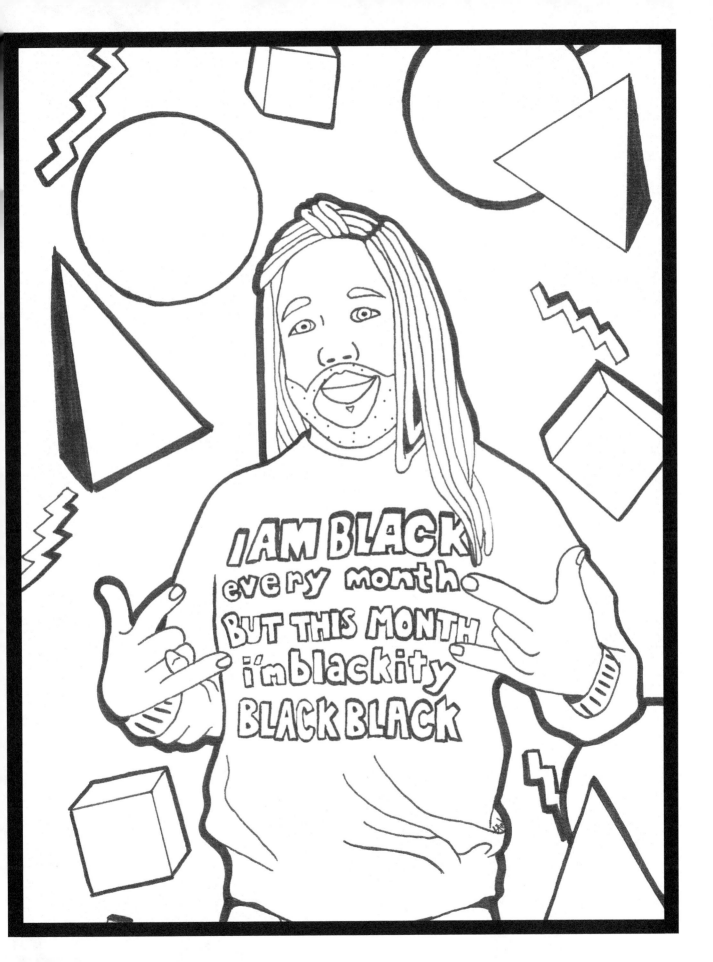

I just love it.
That's the only reason I needed.

Inspired by a chazbruce0 TikTok.

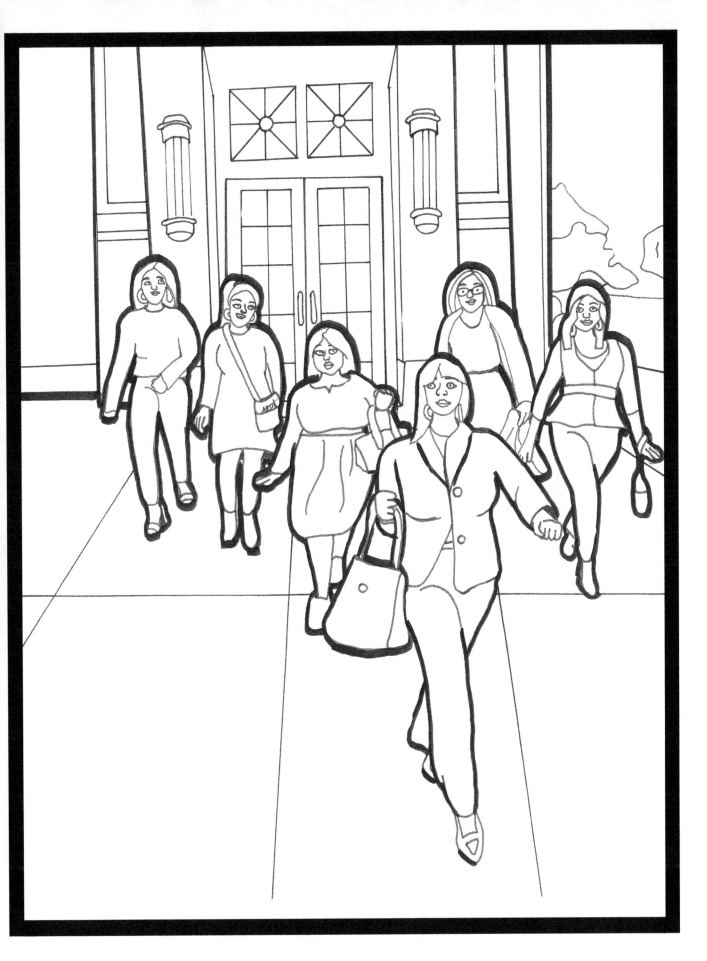

Give me some Black Girl Magic.

Sonya Bruce with daughters;

Latifah Wilson, Ky Bruce, Kell Bruce, Alexis McNeil, Jaquema Jones.

Inspired by a chazbruce0 TikTok.

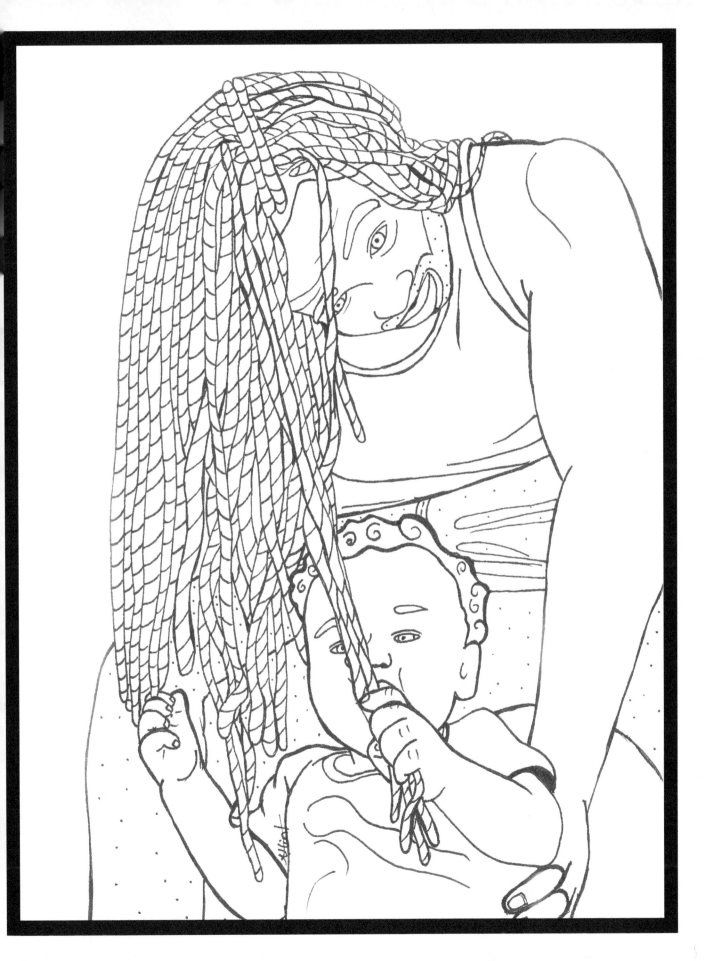

Myles, always playing with daddy's hair.

Inspired by a Bruce family photo.

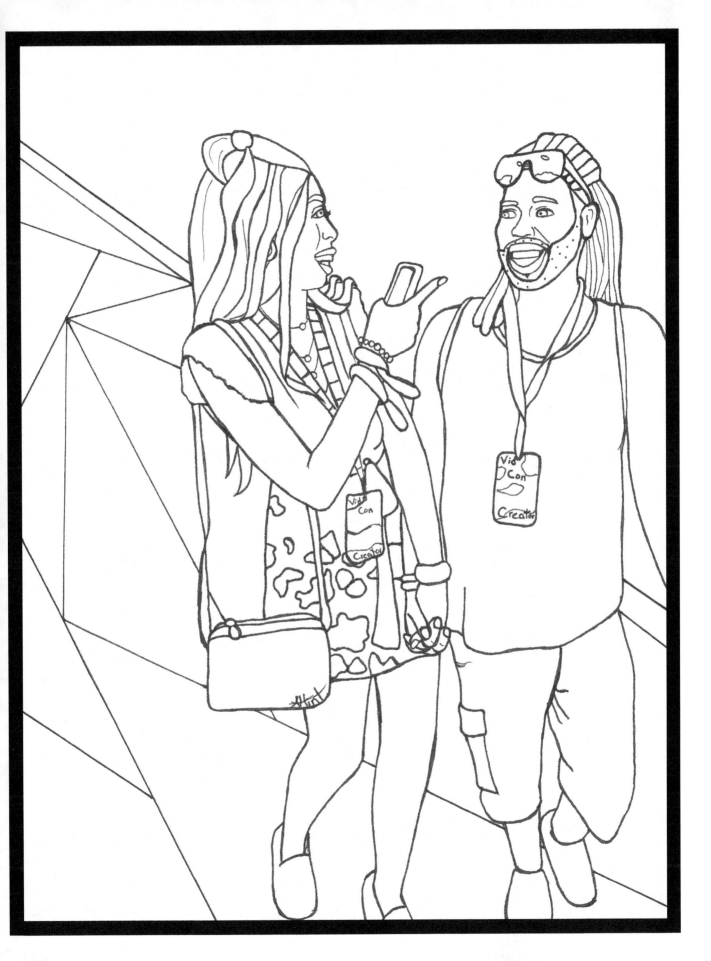

Grabbing a strangers hand at VidCon.

Inspired by a chazbruce0 TikTok.

New shoes, new man.

Inspired by a chazbruce0 TikTok.

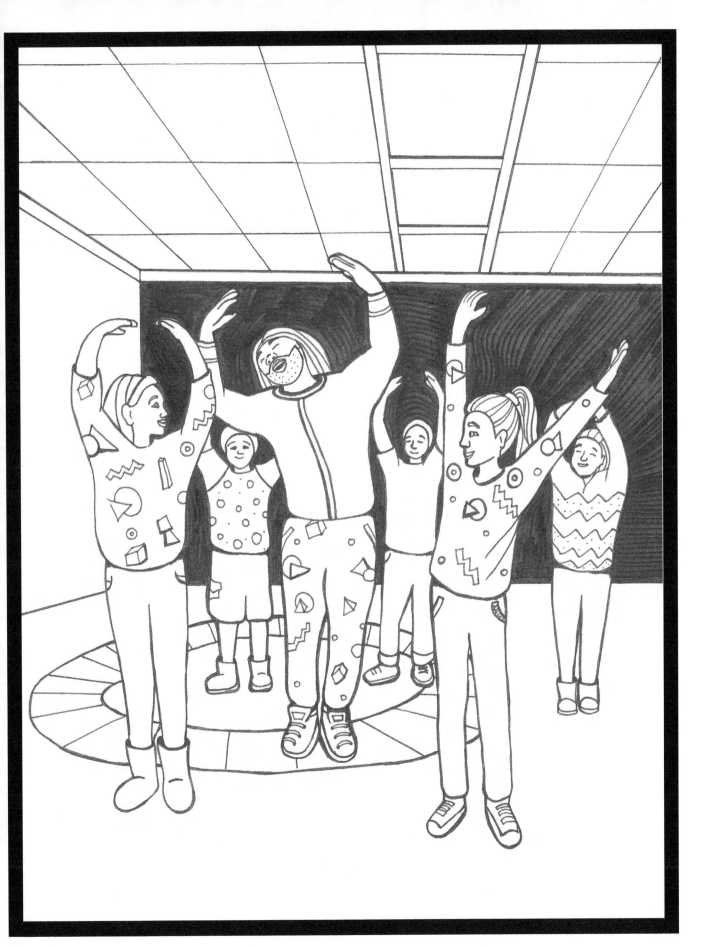

Ballet to hip hop, in music class.

Inspired by a chazbruce0 TikTok.

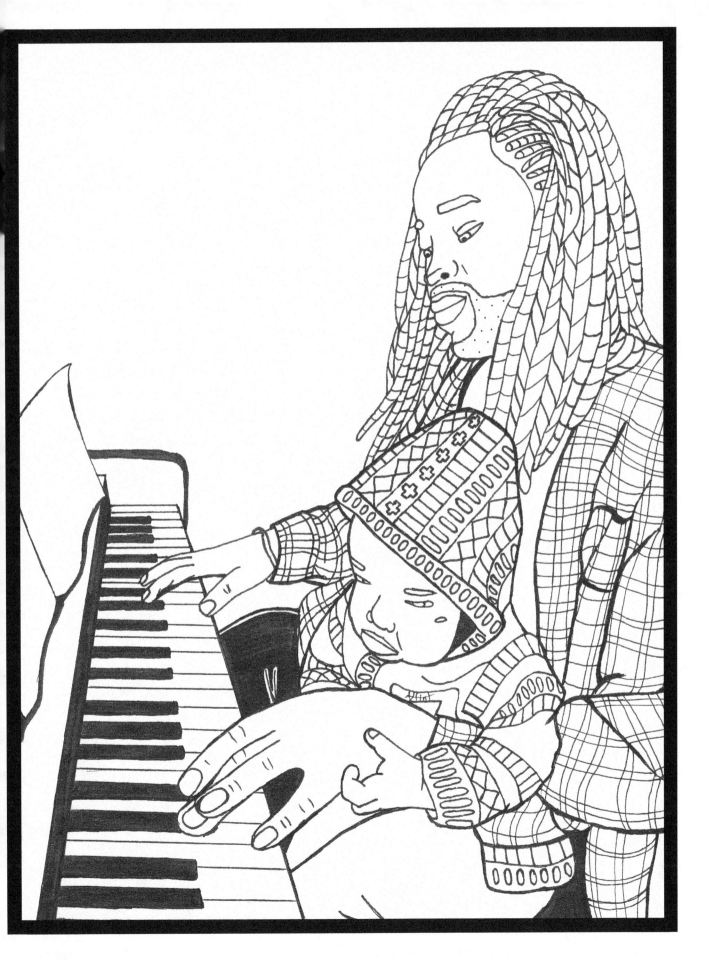

Starting piano lessons young.

Inspired by a Bruce family photo.

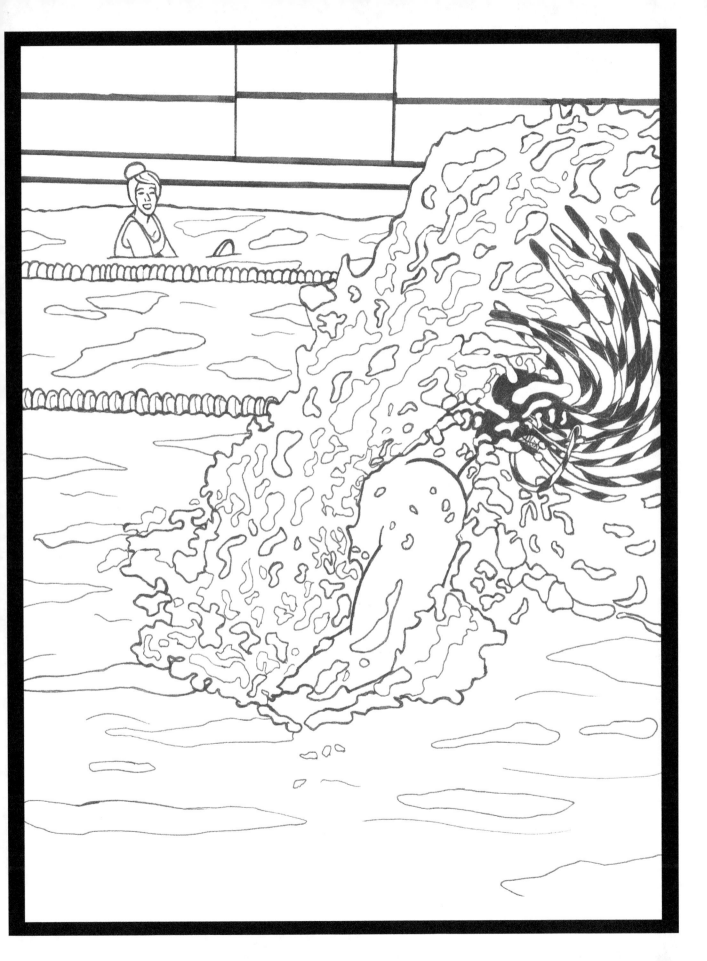

The pool hair toss TikTok.

My oldest daughter Anastasia got to choose her favorite Bruce TikTok.
This one turned out fun. I'm excited to see it colored in a million ways.
-Ashley Lanina

Inspired by a chazbruce0 TikTok.

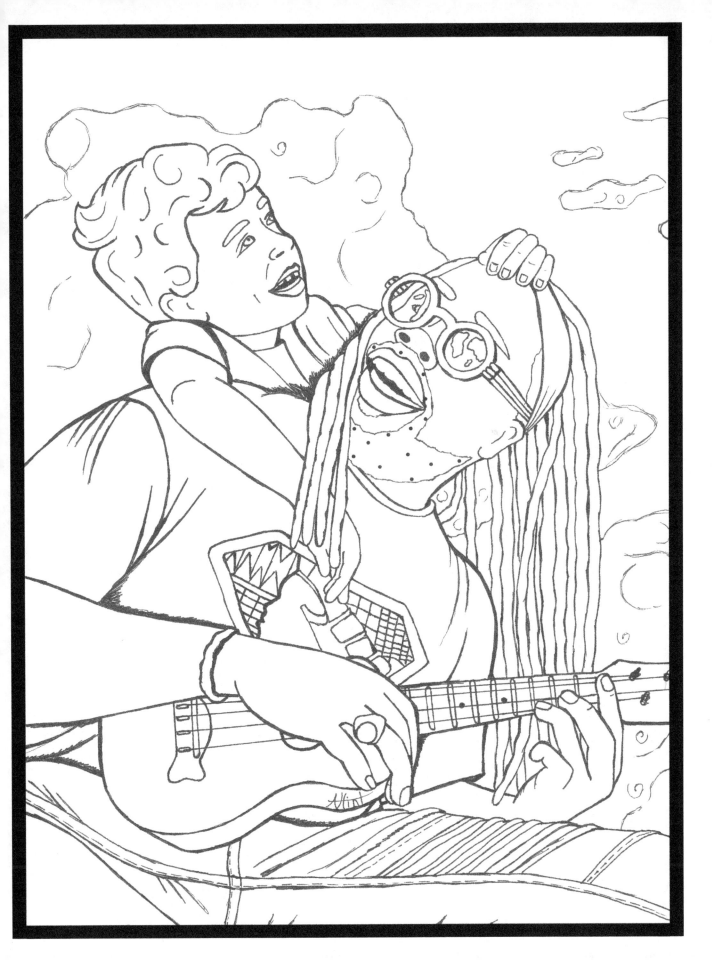

Ellis sneak attacking Daddy.

Inspired by a chazbruce0 TikTok.

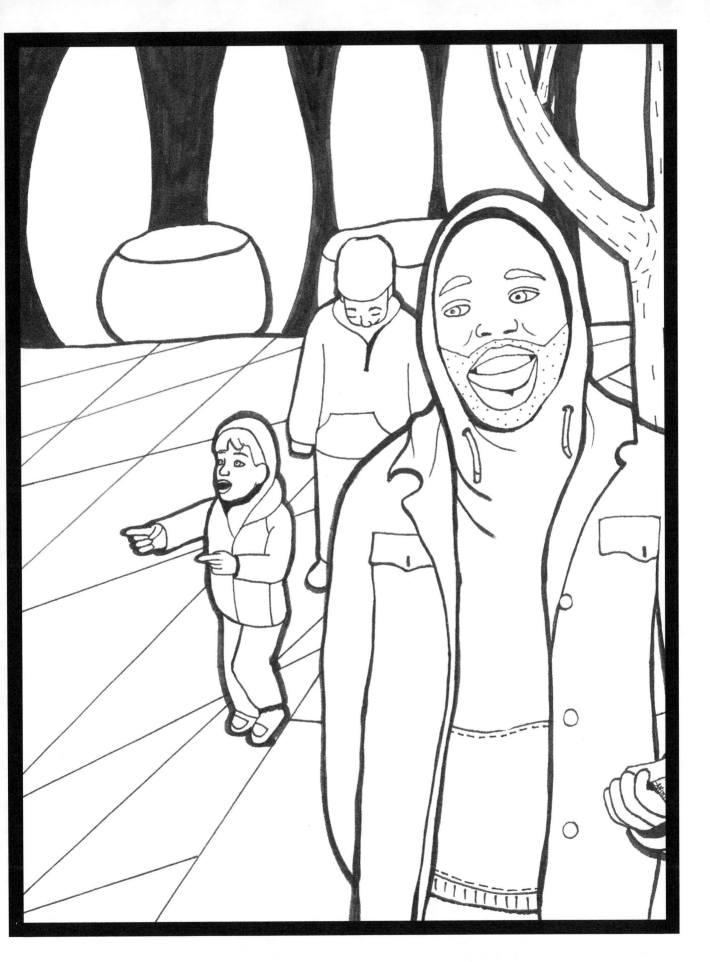

"What up, what up, what up, bro!"

Inspired by a chazbruce0 TikTok.

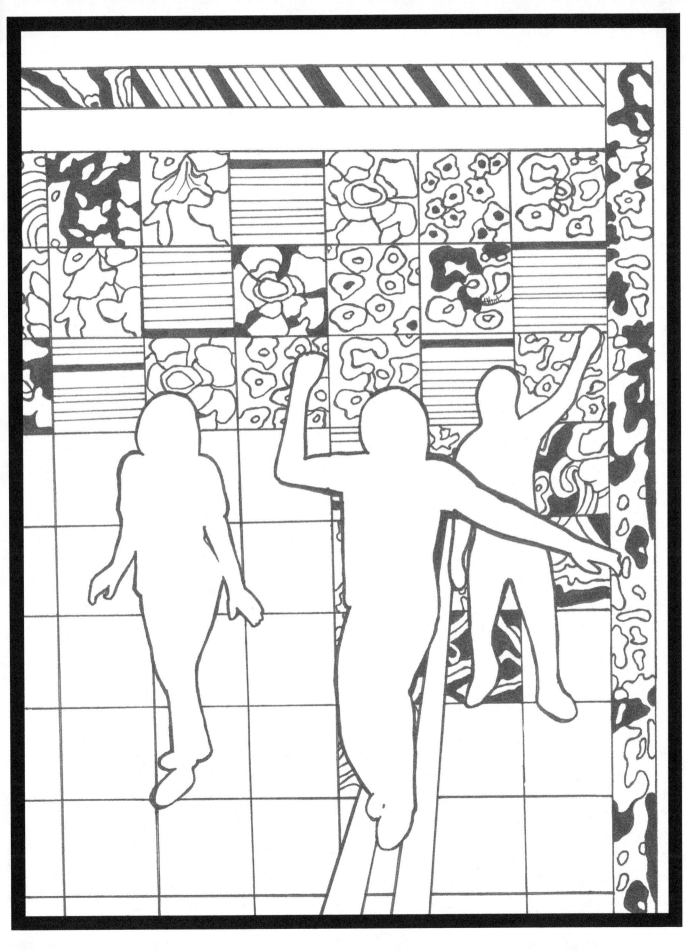

Inspired by the art of quilting.

Chaz Bruce dancing to Jerusalema at a protest.
+
The edge patches of Faith Ringgolds art "Tar Beach".
+
Blank patches for you.

Inspired by a chazbruce0 TikTok and Quilt Art.

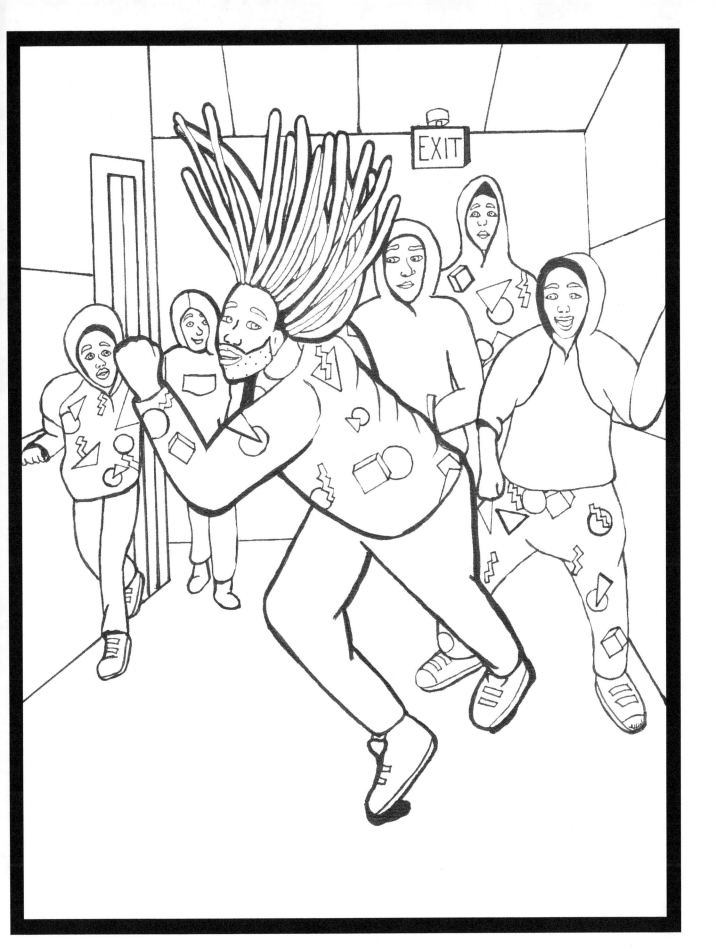

"I didn't realize he had backup!"

Inspired by a chazbruce0 TikTok.

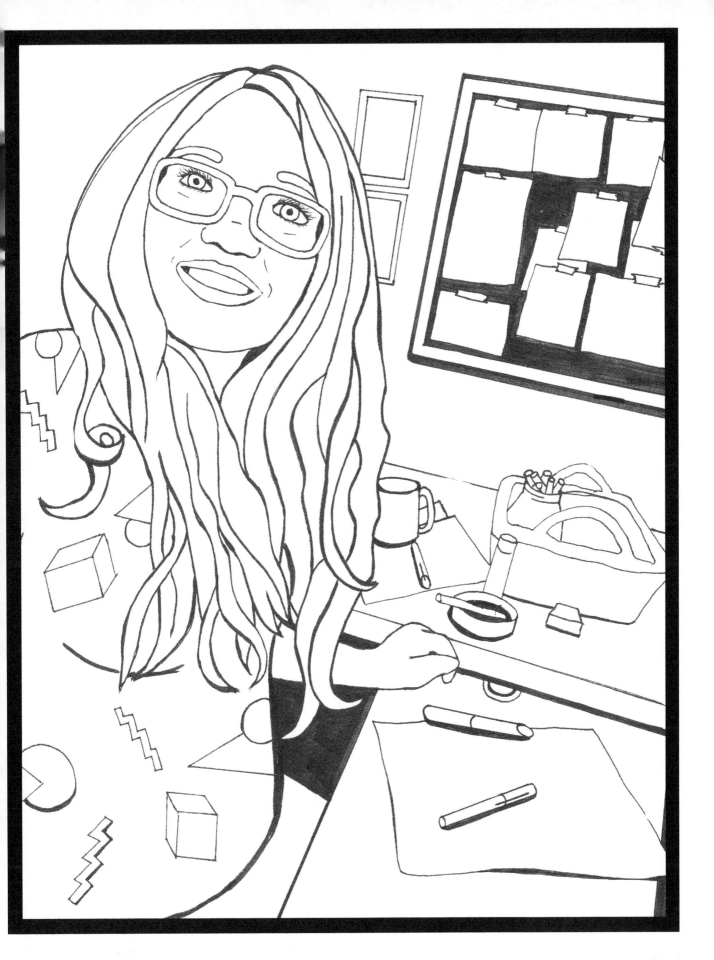

Behind the scenes of creating this book.

"It was inspiring to illustrate."
-Ashley Lanina

Inspired by a two second selfie of Ashley working.

CPSIA information can be obtained
at www.ICGtesting.com
Printed in the USA
BVHW062122300721
613251BV00004B/486